T0198988

My Eid Mubarak Storybook

By
Omer Naqi

Illustrations by
Sierra Mon Ann Vidal

To order additional copies of this book, contact:
Xlibris
1-888-795-4274
www.Xlibris.com
Orders@Xlibris.com

For my Bebo, Nena, and Coco!

Eid Mubarak!

Contents

Emaan and Inaaya Get Ready for Eid with Noorah4

Eid Mubarak from Aminah and Qasim9

Mikael and Ameer's New Eid Trick10

Amna and Ayesha Make Eid Treats for Zia13

Alayna and Anya Get Henna on Eid16

Ibrahim's Surprise on Eid21

Rayyan's Favorite Thing on Eid27

Aleena Can't Wait for Eid31

Zara and Ayza Spot the Eid Moon33

About the Author37

Index39

Emaan and Inaaya Get Ready for Eid with Noorah

Hi, my name is Emaan, and this is my little sister Inaaya. We are both so excited that Eid is coming up! We love Eid because we wear beautiful new clothes and bangles.

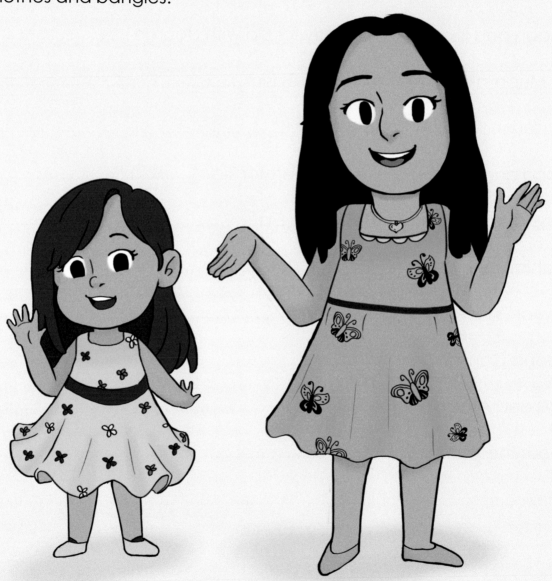

My favorite color is pink, and Inaaya's favorite color is blue.

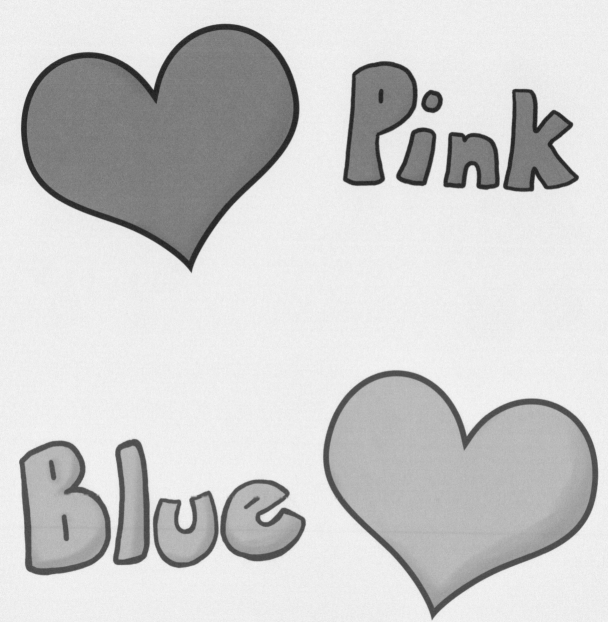

Can you help us pick our Eid clothes?

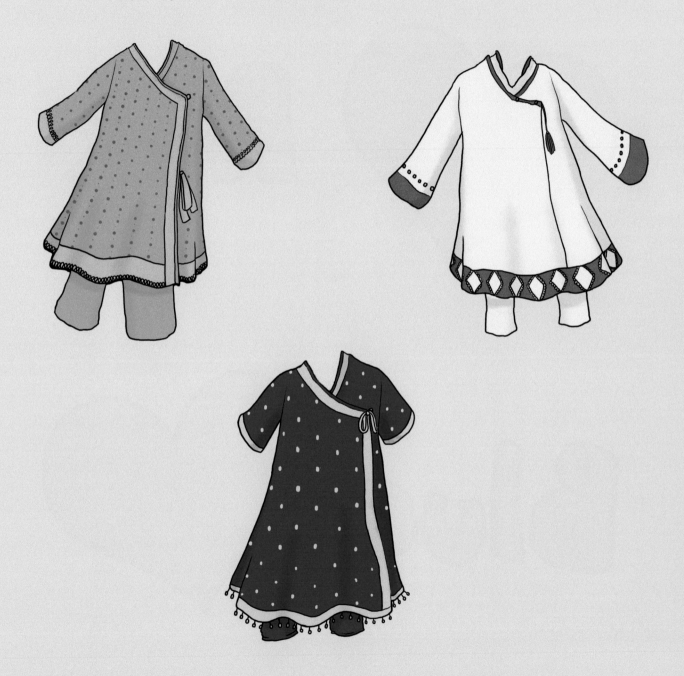

Will you help us choose matching bangles?

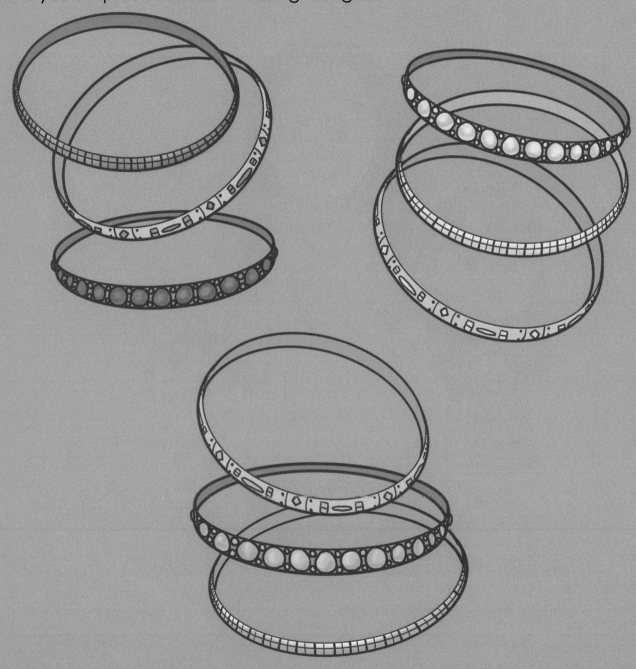

Thank you for helping us with our Eid outfits! Now we are ready for the big Eid party! Do you know what you are wearing on Eid this year?

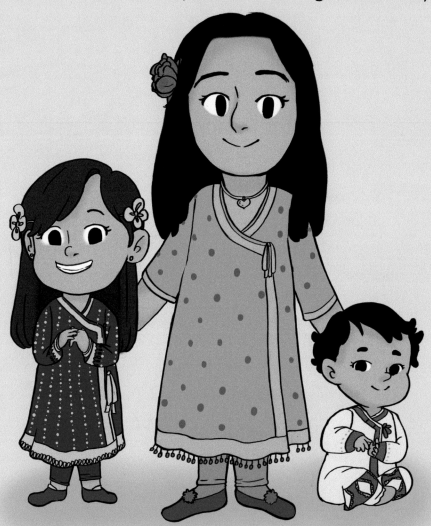

This Eid is very special for us because we are celebrating it with our new baby sister, Noorah! Noorah is too little to wear bangles or get henna. We can't wait till she is a little bit older so we can all have fun together on Eid!

Eid Mubarak from Aminah and Qasim

Hello, I'm Aminah, and this is my baby brother Qasim. He is only two years old, so he is learning how to talk. Eid is coming soon, so I am teaching him how to say "*Eid Mubarak!*" *Eid Mubarak* means "Have a happy and blessed Eid!"

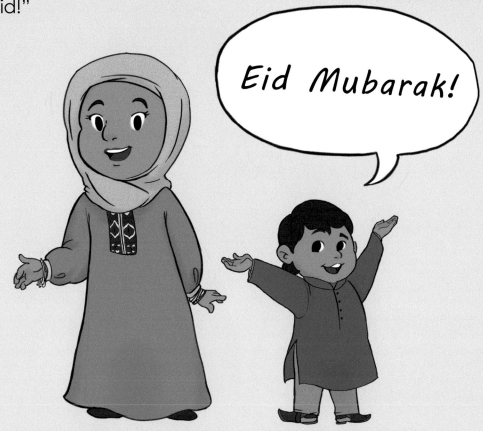

Can you help me teach Qasim to say "Eid Mubarak"?

Great! Say it with me: Eid Mubarak!

Good job! I'm sure that with a little practice, he will learn to say it in no time!

From our family to yours, we wish you Eid Mubarak!

Mikael and Ameer's New Eid Trick

This is Mikael, and his parents are teaching him about Eid.

On Eid day, you greet everyone you meet by wishing them Eid Mubarak and giving them three hugs.

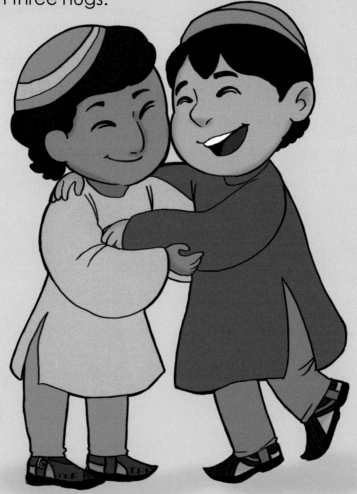

Look at Mikael giving a big Eid hug to his new friend Ameer.

Can you help us count the hugs?

Great! We love getting hugs on Eid! Make sure you also give hugs to your friends and family on Eid.

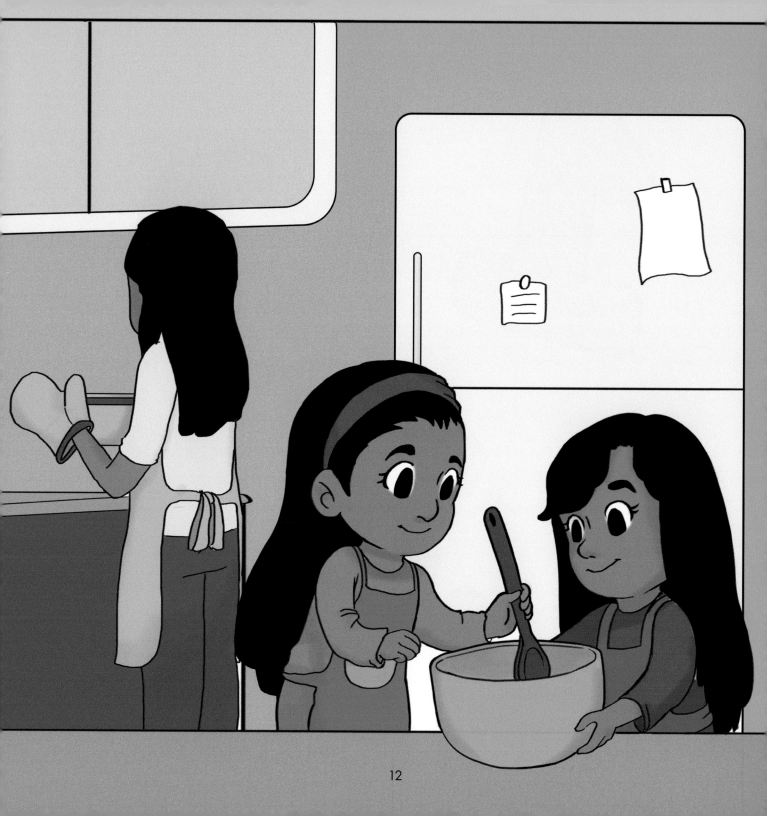

Amna and Ayesha Make Eid Treats for Zia

Amna and Ayesha love to help their mom in the kitchen, especially on Eid because they love making yummy Eid treats. Amna's favorite food on Eid is *kababs* for lunch, and Ayesha loves to have *kheer* (rice pudding) for dessert. Their neighbors Zac, Kyle and Neesha love Eid too because they come over and get to eat all the yummy Eid treats.

Their brother Zia wants to help too, but he's just a baby and makes a big mess in the kitchen! He loves to eat and is waiting for his food to be ready.

Amna and Ayesha serve him his food and tell him to say "*Bismillah*" before he starts eating.

Can you say "Bismillah"? Say it with us: Bismillah! Good job. We should always say "Bismillah" before we eat our food. We hope you also enjoy all the delicious food on Eid!

Alayna and Anya Get Henna on Eid

This is Alayna and Anya's first time getting henna on Eid (also called mehendi in many parts of the world). They are both so excited!

Alayna asks her friend Anya to help her pick a henna design. All three designs are so nice. What a tough decision!

Which of the following should she get?

A butterfly?

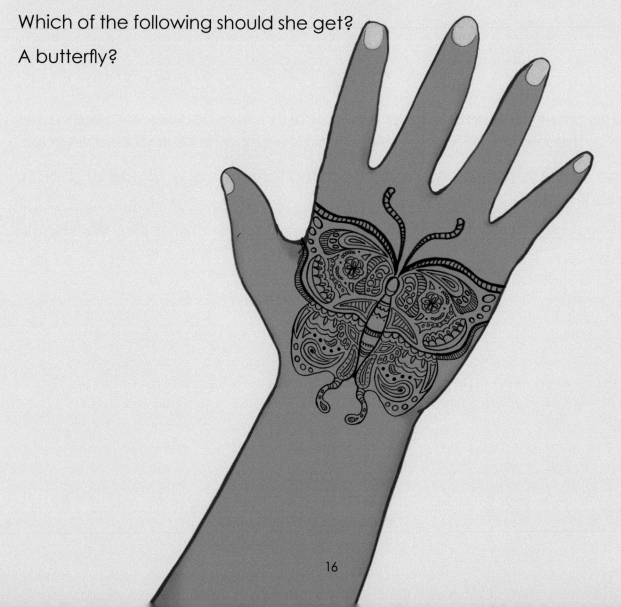

A heart?

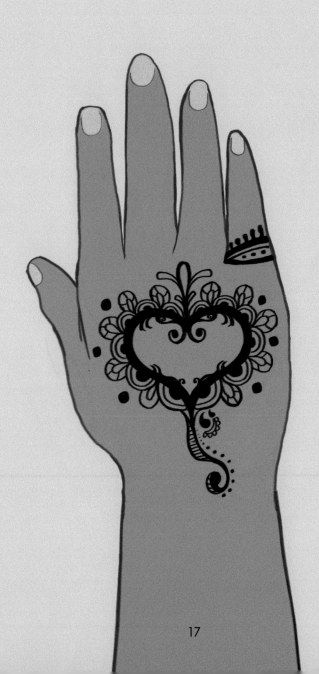

A flower?

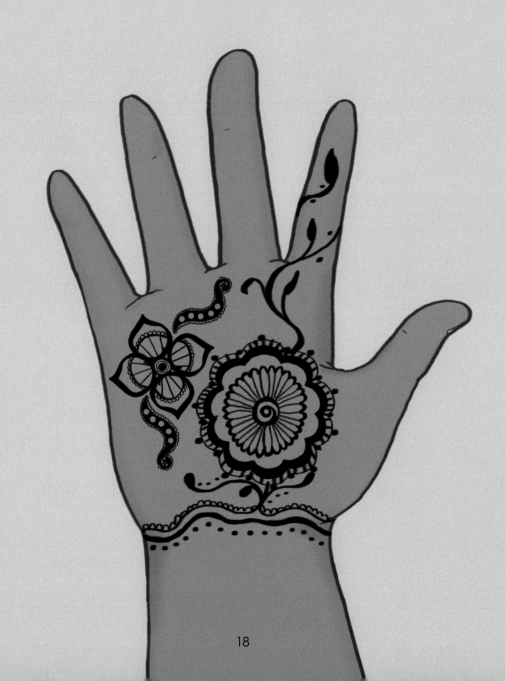

Very nice! Thank you for helping Alayna decide. Look how pretty their hands look!

Their friends at school loved Alayna's and Anya's henna designs. Next time, their friends Phoebe and Marina also want to get henna and join in the Eid celebrations!

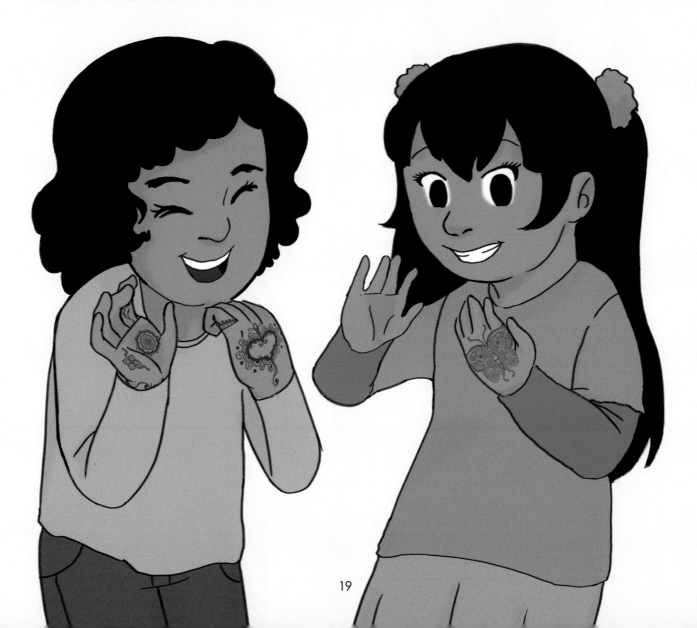

Ibrahim's Surprise on Eid

Ibrahim is very excited about Eid. His parents are planning to give him a big surprise on Eid. Like all other kids, Ibrahim gets an *eidi* (also called "eidiya" across the Arab / African world) from his parents. Every year, Ibrahim tells his parents what he wants for his eidi. Last year, he got a new toy car, and the year before, he got a new schoolbag.

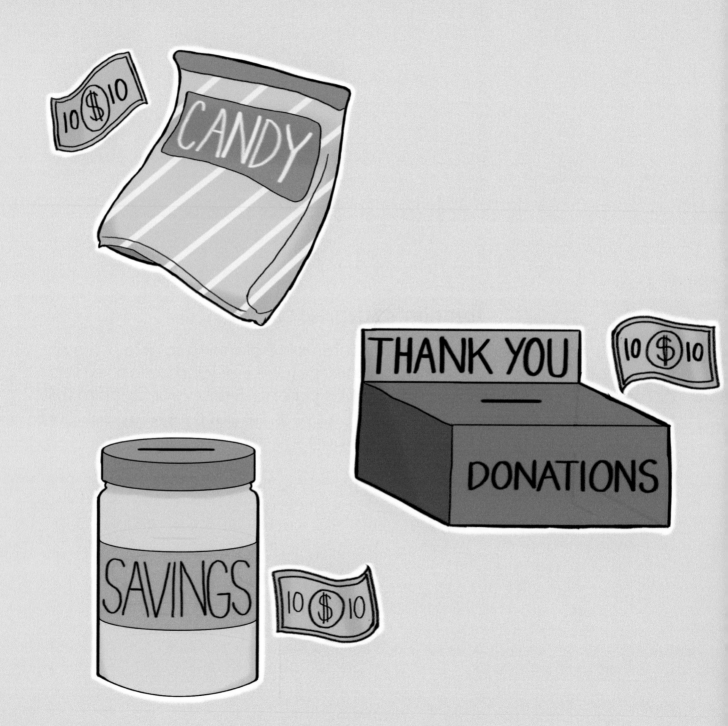

This year, his parents surprised him by giving him money for his eidi.

Ibrahim's father told him, "You are a big boy now, Ibrahim. You are smart and know how to spend your money."

Ibrahim was very excited that he got thirty dollars for his eidi, and he was pleased that his parents trusted him to spend his money wisely.

But he was also confused. Ibrahim knew he was very lucky to get an eidi every year, because there are lots of boys and girls around the world who do not get eidis. This made him sad and think about how he should spend his eidi.

Ibrahim had an idea and decided to divide the money into three equal parts.

He went to the store and spent ten dollars on candies and chocolates and shared the treats with his friends and cousins.

He gave ten dollars to charity to help boys and girls get Eid presents.

And he saved ten dollars in his money bank to keep safe and use in the future.

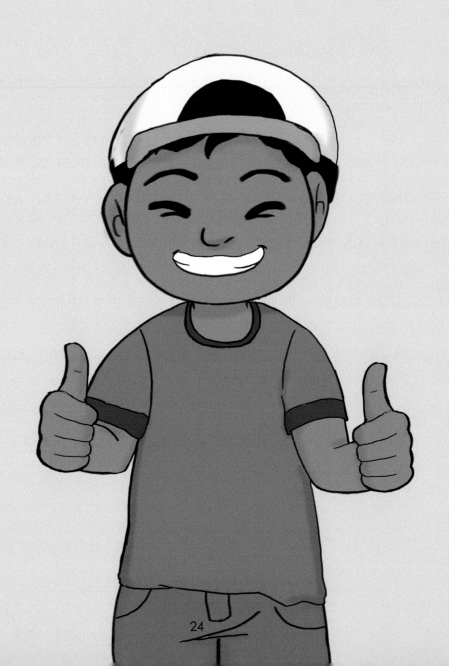

Ibrahim's parents were very proud of him because he didn't spend all the money on himself and shared it with other kids too! Look at Ibrahim and his big smile. It always feels good to share and help others! Good job!

What will you do with your eidi this year?

Rayyan's Favorite Thing on Eid

Rayyan loves Eid because on Eid day, there is no school and he gets to stay home with his family.

Rayyan still wakes up early on the morning of Eid.

But why? He doesn't have to go to school! Let's ask Rayyan.

"I wake up early on Eid day, brush my teeth, shower, and change into my new clothes. Once I am ready, I go to the mosque with my parents. We get balloons and ice cream at the mosque! All our friends and family are there for Eid prayers. I love to see them at the mosque and wish them Eid Mubarak!"

Let's ask Rayyan why he loves Eid and what his favorite thing to do is on Eid day.

"I love Eid because all my cousins come to my house and we play together all day. I love spending Eid day with my cousins and my friends."

Wow! It looks like they are having a great time!

What are your cousins' names? What do you play with them when they come over for Eid?

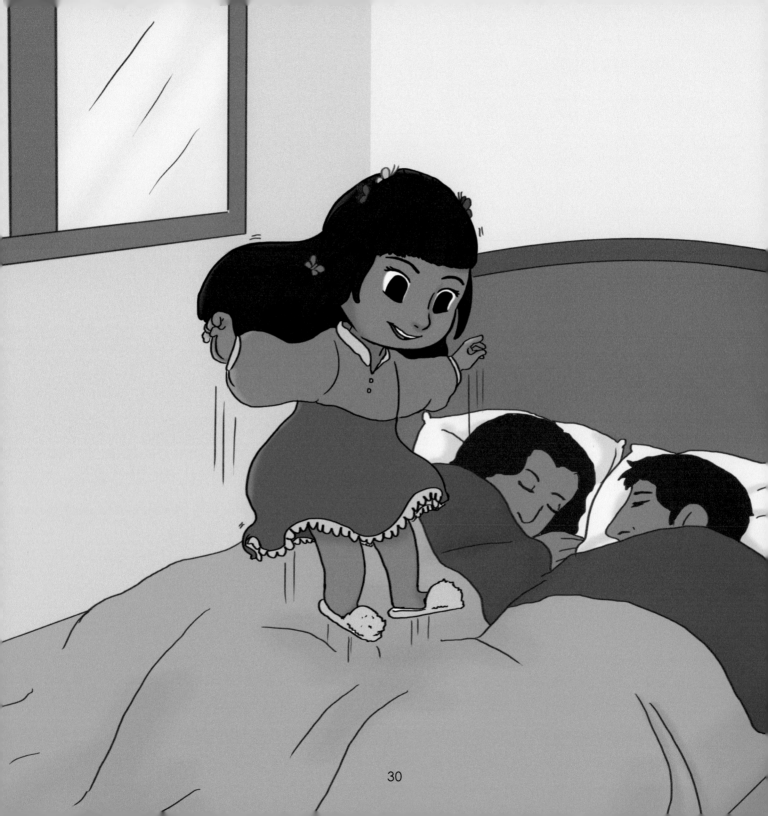

Aleena Can't Wait for Eid

Aleena woke up in the morning and ran to her parents' bedroom and shouted, "Mama, Baba, wake up, wake up! It is Eid! Eid Mubarak!"

Every day, for the last week, Aleena would wake up, go to her parents, and ask them, "Mama, Baba, is it Eid yet? Can I wear my new clothes today? Can I get henna on my hands today? Are the yummy Eid treats ready? What time are we going to the mosque for Eid prayers? Am I off from school? Will I get an eidi today? When are my cousins coming over to play with me?"

This morning, Aleena's parents looked at her, laughed, and said, "Yes, Aleena. It is finally Eid. It is Eid today!"

Aleena has a question for you, are you excited for Eid?

Great! Yes, we are excited too!

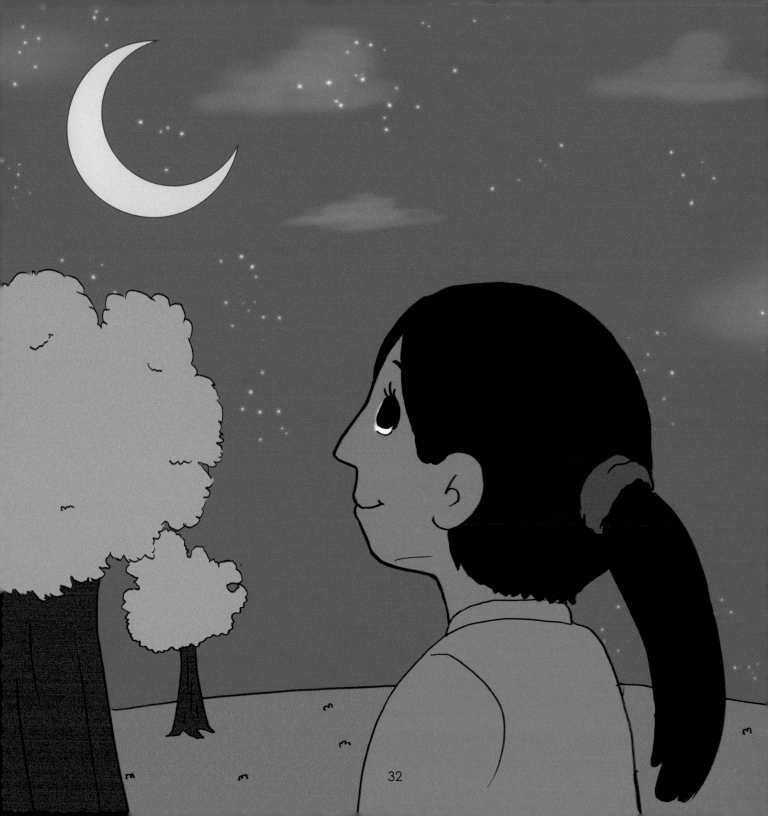

Zara and Ayza Spot the Eid Moon

After sunset, Zara went outside and looked up in the sky. Her sister asked her what she was looking for in the sky.

Ayza asked "Are you looking for a kite? No one is flying a kite today!"

Zara shook her head. "No."

Ayza asked, "Are you looking for a plane in the sky? I can help you look!"

Zara shook her head. "No."

Ayza said, "I know. You are looking for a star to make a wish!"

Zara again shook her head. "No."

Ayza asked, "Then what are you looking for?"

Zara and Ayza's parents also came outside and started looking up at the sky. They explained, "Little Ayza, your sister Zara is looking for the Eid moon. It is a very special moon that means Ramadan has ended and tomorrow we can celebrate Eid."

When Zara and Ayza spotted the moon, they jumped with excitement and then raised their hands to say a prayer (*dua*).

They prayed for a wonderful Eid and a year full of happiness, joy, and blessings for all!

Have you ever tried to spot the Eid moon?

Here is a special Eid gift from me to you! Your eidi. What will you do with your eidi?

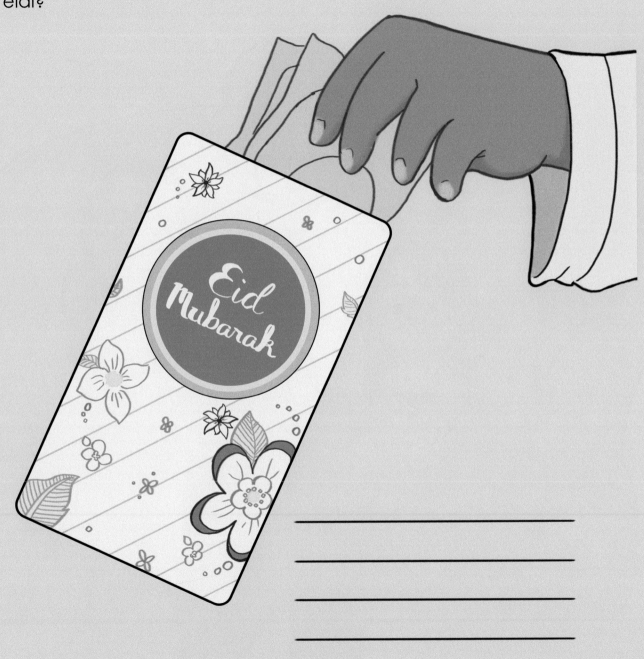

About the Author

Omer Naqi is, first and foremost, a proud dad of three beautiful daughters, a fitness enthusiast, and a banker by profession. People who know Omer all agree that he loves being surrounded by people, whether it is his family, friends, colleagues, or workout buddies. For Omer, there is always time for a coffee accompanied by an entertaining story!

Omer never considered himself as a storyteller or a writer until he became a father. Observing his children, he realized how different his daughters were. The older one is a visual learner, who loves pictures / pop-up books, and the younger one is influenced by the digital era, preferring to use a smart device to listen to stories. Omer endeavors to use children's illustration books using both physical and digital space to reach out to parents the world over to connect with their children and enjoy a good bedtime story!

Omer identifies himself as a Canadian of Pakistani origin. For Omer and his wife Naima, who are raising their kids in Canada, it is important to be well-connected with their heritage while contributing and being part of the diverse Canadian society. The *Eid Mubarak Storybook* is his first project portraying the fun and rich traditions of Eid. He is already working on more illustration books on everyday themes deeply rooted in family values, togetherness, healthy living, and a positive lifestyle.

Index

A
Alayna, 16
Aleena, 31
Ameer, 10
Aminah, 9
Amna, 15
Anya, 16
Ayesha, 15
Ayza, 33

B
Bismillah, 15

D
dua, 33

E
Eid, 9, 11, 13, 16, 21, 27, 31, 33, 35
Eid day, 10, 27, 29
Eid hug, 10
eidi/eidiya, 21, 23, 25, 31, 35
Eid moon, 33
Eid mubarak, 9–10, 27, 31
Eid prayers, 27, 31
Eid treats, 13

H
henna/mehendi, 8, 16, 19, 31

I
Ibrahim, 21

K
kababs, 13
kheer, 13

M
Mikael, 10
mosque, 27, 31

N
Noorah, 8

Q
Qasim, 9

R
Ramadan, 33
Rayyan, 27

Z
Zara, 33
Zia, 15

Printed in the United States
By Bookmasters